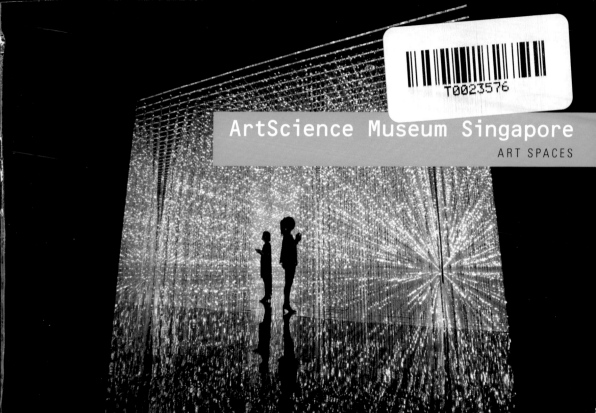

ArtScience Museum Singapore

ART SPACES

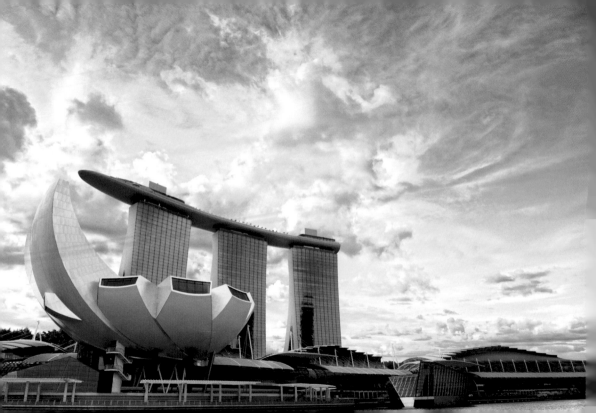

# AN ICONIC CULTURAL LANDMARK: ARTSCIENCE MUSEUM SINGAPORE MARINA BAY SANDS

Instantly recognisable, ArtScience Museum is situated on the promontory of Marina Bay, Singapore, facing towards the city. As the cultural component of the Marina Bay Sands integrated resort, the museum's distinctive architecture stands out like a 'welcoming hand of Singapore'. Designed by acclaimed architect Moshe Safdie, the iconic building has become a powerful cultural symbol of twenty-first century Singapore. Its remarkable structure resonates with locals and leaves a lasting impression on tourists. Developed from a natural form and abstracted through geometry, the building's shape expresses a compelling, contemporary spirit while also offering a view into the future.

The mission of the Museum, to explore the point where art, science, culture and technology come together, is reflected in the architecture itself. In the short span of time since its 2011 opening, ArtScience Museum has distinguished itself as a cultural landmark through its thought-provoking and culturally innovative exhibitions and programmes. This unique, audience-centric museum flourishes from the intersections of art and science, where innovation and new ideas are formed. In so doing, it has its finger on the pulse of the future, anticipating and even creating it.

↑
*Crystal Universe* (2015), an interactive light sculpture, is one of the most popular installations of *Future World: Where Art Meets Science*, a permanent but ever-changing exhibition at ArtScience Museum. teamLab, *Crystal Universe* (2015). Endless interactive light installation. More the 170,000 LED lights. Sound: teamLab

←
A panoramic view of the integrated resort Marina Bay Sands. In the foreground is the iconic ArtScience Museum.

→
The uniquely shaped 'petals' of ArtScience Museum resemble a lotus floating on water. Here they rise majestically into the tropical evening sky, forming an arresting reflection on the waters of Marina Bay.

→→
A view of ArtScience Museum from the Helix Bridge on the left. In this image the Museum's facade is lit by the work of teamLab, *What a Loving, and Beautiful World – ArtScience Museum* (2016). Endless interactive digital installation.
Calligraphy: Sisyu
Sound: Hideaki Takahashi

## BIRTH OF AN ICON

In a bid to develop its tourism industry, the city-state of Singapore embarked on an ambitious land reclamation project in 1971. The result was the creation of Marina Bay and its waterfront promenade. ArtScience Museum was conceived in 2006 as part of the Marina Bay Sands integrated resort bid, which favoured a mixed-use development. The proposed design for the Museum was equally bold, reflecting the city's forward-looking spirit.

In designing ArtScience Museum, Safdie pursued the concept of timelessness. In adhering to the guiding principles of 'purpose', 'tectonics' and 'place', he sought to create a poetic and compelling building that would be iconic yet integrate easily into the cityscape of Singapore. Like many of Safdie's creations, the design of ArtScience Museum was also shaped by a responsibility towards the environment, with a strong emphasis on sustainability.

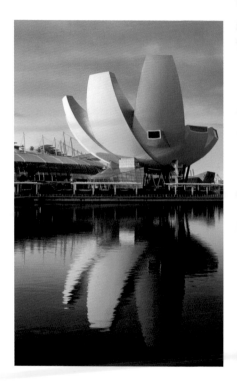

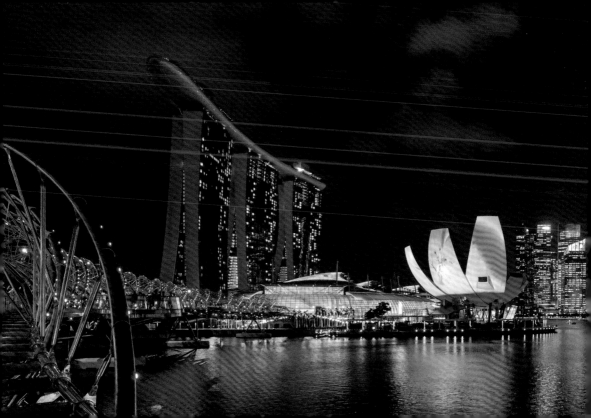

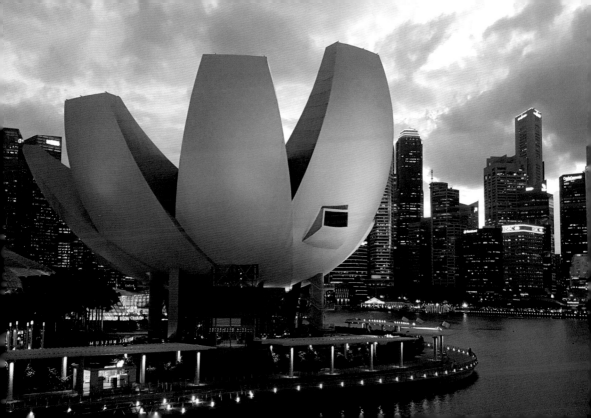

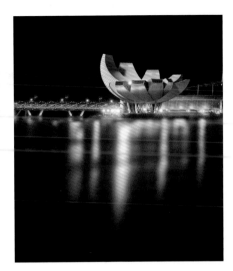

*For me, design has been a search to produce a compelling spatial geometry in complete harmony with formal imperatives of the programme, generated by a cohesive resolution of all the building's systems and naturally rooted in its site.*
– Moshe Safdie

## DESIGNING WITH PURPOSE IN MIND

ArtScience Museum's inspiring form echoes the power of its mission, embodying both aesthetics and function and combining culture and technology. Like a lotus rising above the turmoil of the everyday, the building captures both light and water; it seems to draw energy from the life-giving forces of nature in order to rejuvenate and energise the people who visit and work in it. The form of ArtScience Museum has also been likened to the fingers of an open hand, making a gesture of welcome; however, it is the rigorous abstraction of the Museum's shape that lends it a deep, poetic power. Free from any fixed symbolism, visitors are encouraged to imagine their own diverse interpretations of the building.

The organisation of space within ArtScience Museum prioritises the needs of its users. The flow, orientation and strategic placement of functions are mapped out to encourage the smoothest, most enjoyable visitor flow. In fact, the visitor journey begins a considerable distance before entering the building. To reach the entrance, visitors must pass by a body of water often filled with lilies, mirroring

←←
With its bulbous, geometric form, ArtScience Museum dominates the skyline of Singapore's central business district.

←
At night ArtScience Museum shines like a beacon, dazzling with its architectonic form.

→
A sketch of ArtScience
Museum by Moshe Safdie.

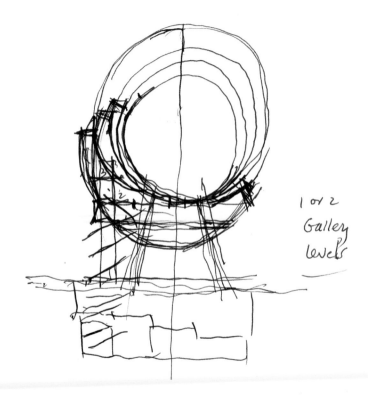

1 or 2
Gallery
levels

the voluminous 'petals' of the Museum reaching for the skies above them.

Entering a sort of glass pavilion, visitors congregate in a mini agora with a café on the ground floor. Here large lifts transport people to the upper or lower galleries. Visitors enter and exit from the same place, giving them an opportunity to orient themselves. The glass lifts provide the main route for vertical movement while the galleries radiate outward from the centre of the lotus form, creating an organic, circulatory flow of visitors on each floor. The gallery spaces on the upper levels are connected but simultaneously defined by the boundaries of each of the ten 'petals'. A total of 21 gallery spaces spanning 5,000 square metres are spread across four levels.

↓
The geometrical development of ArtScience Museum's structure by Safdie Architects.

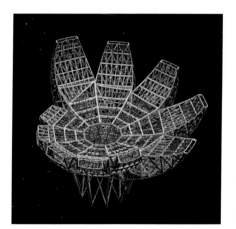

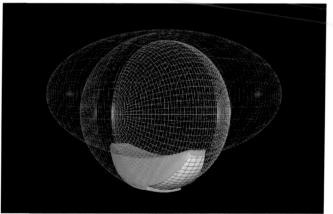

→→
Cross-section plans of
ArtScience Museum by
Safdie Architects.

→
A technical drawing by
Safdie Architects showing the
development of geometry in
ArtScience Museum's design.

↘
Cross-section plans of
ArtScience Museum by
Safdie Architects.

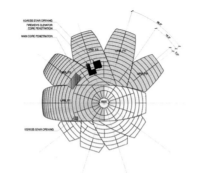

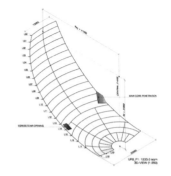

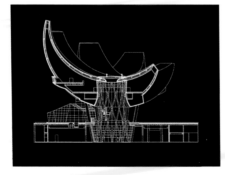

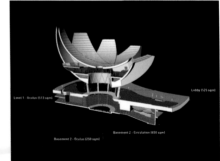

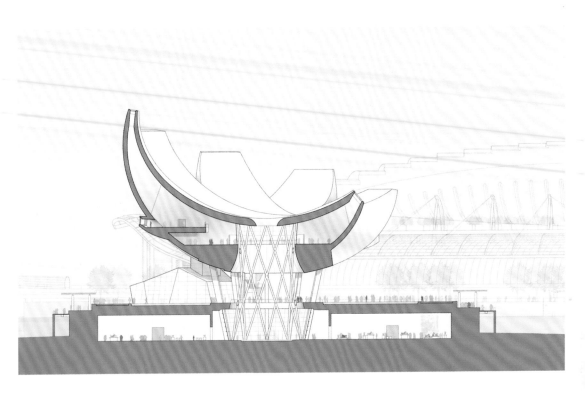

→
A view into the oculus
(a circular opening in the
centre of the inverted dome)
from the galleries on Level 3.

→→
The high ceilings of the
galleries on Level 3 cater
to oversized works such as
*Walter* by Dawn Ng, displayed
as part of the *Floating Utopias*
exhibition in 2019.

ArtScience Museum hosts exhibitions with collections that come from noted museums around the world. All gallery spaces must therefore meet international museum standards and requirements. As such, every gallery and temporary storage space is fitted with temperature and Relative Humidity (RH) controls. The upper galleries boast double height spaces ranging from between 8 and 12 metres in height. They are lit by suspended lighting tracks and, most importantly, natural light which cascades down the tips of the 'petals' and radiates from the central atrium. Designed to avoid the notion of a white cube space, the galleries on Level 3 instead offer options to display oversized installations and works that may benefit from the day's changing light. When low lux levels are required – for example for the display of light-sensitive materials or the staging of film or video works – the galleries can be easily transformed into black boxes by integrated lighting control mechanisms and blinds. More contained galleries at the Basement 2 Level provide additional flexible space, allowing ArtScience Museum to accommodate a variety of exhibitions and artworks.

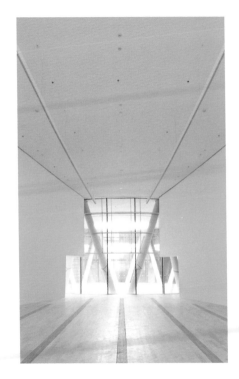

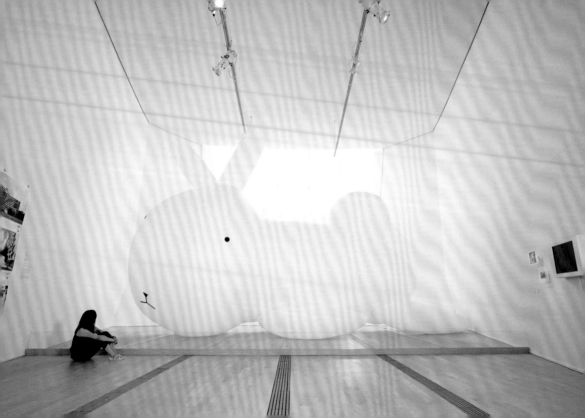

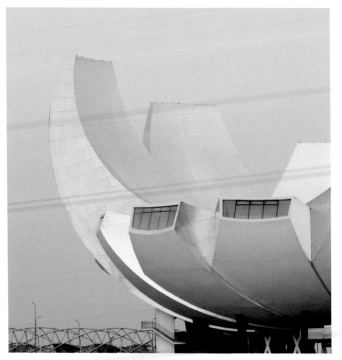

## TECTONICS: MATERIALITY AND TECHNOLOGY OF THE BUILD

Derived from the Greek word *tektonikos*, 'tectonics' refers to the materiality of architecture and the technology of building in architectural terms. It is normally used to describe the form of a building derived from its structure, but also encompasses the deeper meanings of the structure itself, aside from the pragmatics of its build.

ArtScience Museum's building consists of two main parts: a base that is embedded in the ground – surrounded by ponds – and an asymmetrical spheroid with ten radiating 'petals' of different heights and widths spaced around 360 degrees. The petal-like extensions rise skyward, reaching as high as 60 metres above ground. Cantilevered trusses radiate from a central steel core, separating the galleries and splitting to define the edge of each 'petal' as they curve upwards. The weightless, hovering quality of the spheroid and the simplicity of its form belie the complexity of the building's design and construction.

Due to the asymmetry of the structure, there was a risk that the building might lurch sideways.

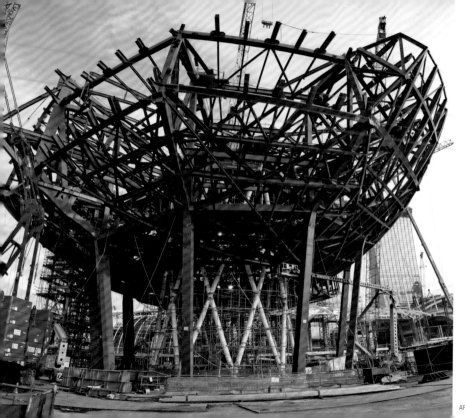

← ←

The sides of the petal-like extensions are clad in shimmering steel. They form a striking contrast to the smooth white surface of fibre-reinforced polymer.

←

Construction of the steel structure of ArtScience Museum (2007–10).

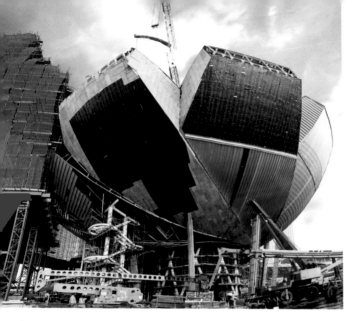

↑
Stainless-steel cladding works in progress during construction of ArtScience Museum (2007–10).

To mitigate this Arup, the project's engineers, designed a diagrid core to stabilise the elaborate steel lattice structure. The elegant fluting of the diagrid construction helped to maintain a transparent and open view throughout the core of the building, ensuring a clear line of vision out towards the sky.

To form the lattice structure, 5,000 unique steel elements were manufactured with exacting precision. The complex geometry involved in producing and putting together this giant 3D puzzle was made possible using a wireframe model and 3D modelling software. The modelling software also helped to reduce the time required to complete the project.

If steel gave the building its span and structure, and glass brought it natural light and transparency, then fibre-reinforced polymer delivered lightness and a seamless aesthetic to the Museum. This polymer – a durable, lightweight material used in the construction of high-performance racing yachts – envelopes the building almost entirely. Bead-blasted, stainless-steel panels cover the sides of the petals, creating a shimmering contrast to the matt polymer sheath.

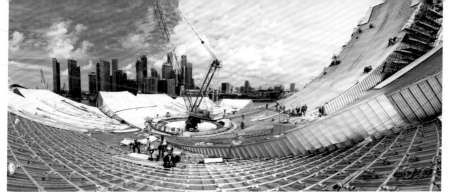

←
An overview of the top of the diagrid structure during the construction phase (2007–10).

↙
Workers applying waterproofing works over stainless-steel cladding before installing an outer layer of fibre-reinforced polymer (2007–10).

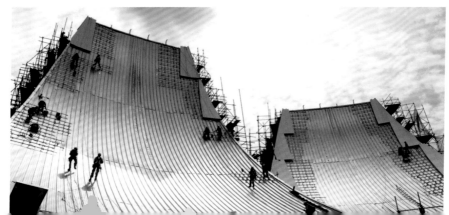

→
A double reflection of
ArtScience Museum's
silhouette is captured in
Anish Kapoor's *Sky Mirror*
(2010) and the lily pond.

## HUMANISING SPACE: LIGHT AND WATER

Rainwater collected by the dish-like roof is channelled through it and fills an interior pond at the centre of the building positioned at the Basement 2 Level. From the galleries on Level 3, large windows provide vistas on to the reflecting pool below and the open space, or oculus, at the top of the building above. This openness allows for contact with the natural elements of water and light, humanising the interior space and creating a dialogue with the outside world.

This introduction of natural light into the core of ArtScience Museum, as well as via the skylights at the tip of the 'petal' extensions, creates a sense of vitality and connection with the wider environment. Shadows are cast on internal walls and floors at different times of the day, sculpting the space in the upper galleries. In the basement, daylight permeates the core, striking the intersecting steel structure and interacting with the water of the interior pond to form a kaleidoscope of dancing shadows. Water's reflective properties and the strong daylight of Singapore are celebrated in

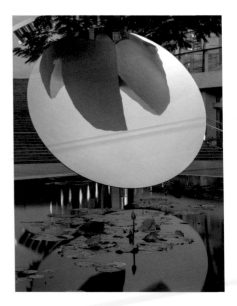

the surrounding lily ponds that mirror the bulging base of the Museum's spheroidal form. In the evenings, the mesmerising hues of sunset dance across the pond in warm orange and purple hues.

## SUSTAINABILITY

Designing with a high regard for the quality of life of its users entails designing with sustainability in mind. ArtScience Museum scores highly on sustainability and has won many awards for its eco-practices. The harvesting and recycling of rainwater in the oculus, the use of natural daylight and the strategic placement of air-conditioning units are among the features receiving acclaim. Nearly 1,400,000 litres of rainwater are collected and recycled every year through the oculus; this water is then reused for landscaping, maintaining water features and flushing toilets. Energy-saving initiatives such as the use of LED lights and a programmable lighting system enables the museum to be 47 per cent more energy-efficient than similar rated buildings. To conserve energy, air conditioning is built into the floors of ArtScience Museum instead of cooling the vast upper volumes of the galleries. It can thus keep visitors, works of art and artefacts cool at their individual heights.

For attaining some of the highest environmental performance standards in the areas of water, energy and waste management – as well as sustainable

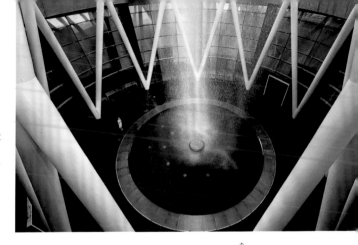

↑
Rainwater is collected in the internal pond via the oculus.

purchasing – ArtScience Museum was awarded the highly prestigious Leadership in Energy and Environmental Design (LEED®) Gold Certification in 2018. It was the first museum in Asia Pacific to receive this accreditation. The sustainable features and efforts of ArtScience Museum have not gone unnoticed locally; in 2012 it was awarded the Green Mark Gold Award by the Building and Construction Authority of Singapore.

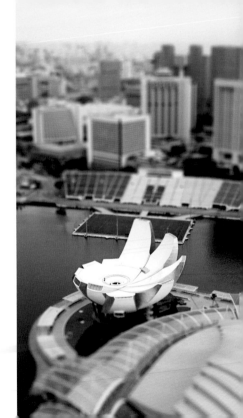

→
An aerial view of ArtScience Museum at the promontory of the Marina Bay Sands integrated resort.

## PLACE: SETTING THE MUSEUM IN CONTEXT

Besides purpose and tectonics, the third guiding principle of Safdie's approach to architecture is 'place'. In other words, 'a rootedness in time and place' as an understanding of context is fundamental to good design. Having worked and interacted with the people of Singapore for over 30 years, Safdie easily grasped and conveyed the essence of Singapore in the museum's design. ArtScience Museum was to belong not just to the people of Singapore but also to the people of the world, for Singapore has always been cosmopolitan, global and forward-thinking in its outlook. Instead of employing formal elements to convey the cultural essence of a place, a more abstract approach was adopted to capture the diverse spirit of Singapore. This direction worked well as it allowed room for imagination, subjectivity and exploration – values that align with the work of the museum itself.

Resonance with ArtScience Museum's physical setting, its relationship to the promenade and both the public and private spaces surrounding it were all critical in considering context. Singapore's climate

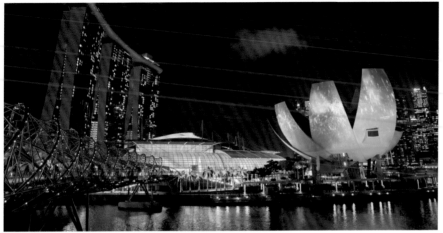

←
A night-time view of ArtScience Museum. The light projection on its lotus-like form was the work of international art collective teamLab, *What a Loving, and Beautiful World – ArtScience Museum*. The display formed part of the iLight Marina Bay event in 2016.

and geographical location were also key components in this analysis. Conscious that Singapore has no seasons and experiences heat and tropical monsoon rains throughout much of the year, the architects avoided building a glass structure that would have quickly become a greenhouse. The use of fibre-reinforced polymer as the dominant surface cladding for the museum building was therefore an ideal choice, based on the material's known abilities to withstand strong winds, heat and rain. For its sensitivity to true human-based design and a sympathetic approach to sustainability and the environment, ArtScience Museum won the International Architecture Awards in 2016.

→→
*Animaris Ordis* (2006), a
wind-powered sculpture by
Theo Jansen, is set in motion
at the base of the rain oculus
in ArtScience Museum.

## ARTSCIENCE MUSEUM:
## WHERE EVERYTHING CONNECTS

ArtScience Museum's curatorial philosophy is to explore the intersection of art, science, technology and culture. Characterised by innovative exhibition-making with a multi-disciplinary approach and a focus on the immersive, experiential and participatory, it has distinguished itself as one of the leading cultural institutions in the region.

The Museum is not bound to the display of a collection, and thus has the freedom to explore ideas and storytelling beyond objects. It is able to choose its collaborators and to commission new work. ArtScience Museum values collaboration across diverse fields and disciplines. Working closely with local and global communities of artists, scientists, technologists, researchers and other creative minds, ArtScience Museum breaks down intellectual borders and develops creative platforms on which ideas may interact and evolve. Its exhibitions and programmes reflect a strong grounding in science and an understanding of how art can create emotional connections.

Always aiming to be cutting-edge in its approach, ArtScience Museum engages new technology to effect conversations about the human condition in an age of constant change and volatility. Raising questions and possibilities, its exhibitions and programmes provide multiple lenses through which to glimpse many possible futures.

This inter-disciplinary, collaborative and future-centred ethos has been applied to both permanent and temporary exhibitions in ArtScience Museum. One notable example was the exhibition *Da Vinci: Shaping the Future* in 2014, one of the first major shows developed by Honor Harger in her role as Executive Director. This exhibition marked a turning point for the Museum, where the curatorial focus of exploring the intersection of art and science became more evident and prominent.

Since that point ArtScience Museum has become a trusted partner of both private and public institutions, working successfully with local and international museums and scientific institutions on a range of successful exhibitions. These include *The Deep* (2015), *Collider* (2015), *Big Bang Data* (2016), *Journey to Infinity: Escher's World of Wonder* (2016),

*NASA – A Human Adventure* (2016), *The Universe and Art* (2017), *HUMAN+* (2017), *Art from the Streets* (2018), *Wind Walkers: Theo Jansen's Strandbeests* (2018), *Minimalism: Space. Light. Object* (2018), *All Possible Paths: Richard Feynman's Curious Life* (2018), *Floating Utopias* (2019), *Wonderland* (2019), *2219: Futures Imagined* (2019), *Planet or Plastic?* (2020) and *Virtual Realms: Videogames Transformed* (2021).

In 2016 ArtScience Museum opened a permanent but ever-changing exhibition, *Future World: Where Art Meets Science* – a collaboration with the Japanese art and technology collective teamLab. The show redefined the Museum experience with immersive and interactive displays, entirely rendered using digital technology.

*Study the science of art. Study the art of science.*
*Develop your senses – especially learn how to see.*
*Realise that everything connects to everything else.*
– Leonardo da Vinci (1452–1519)

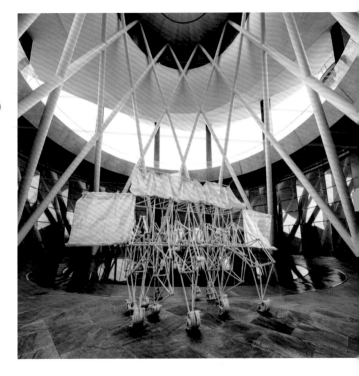

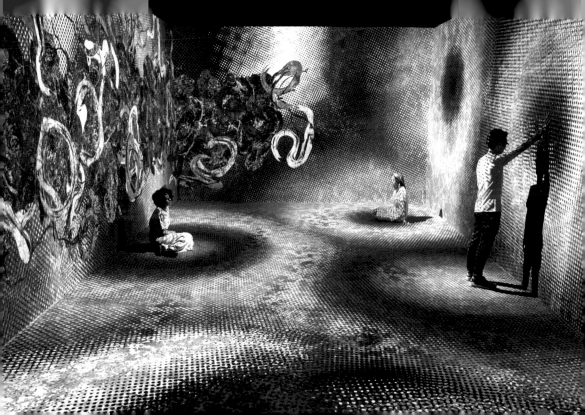

## FUTURE WORLD: WHERE ART MEETS SCIENCE

*Future World: Where Art Meets Science* is
the result of a creative collaboration between
ArtScience Museum and teamLab. An international,
inter-disciplinary art collective based in Japan,
teamLab is a natural ally for ArtScience Museum.
The collective consists of hundreds of artists,
programmers, engineers, computer graphics
animators, mathematicians and architects who
work collaboratively. teamLab leads the field in
its use of technology to create memorable and
powerful immersive and interactive artworks.

    *Future World*, as the name implies, represents
a world of the future created within a museum
context. Innovative and compelling, it breaks
down the traditional concepts of what a museum
should be. This permanent but ever-changing
exhibition is part artistic encounter, part learning
experience, part creative play, part science
and part technology. The overall experience
of *Future World* is not only sensorially dynamic
and impactful, but also carries deeper meaning
alongside poetic narratives.

← teamLab, *Four Seasons, a
1,000 Years, Terraced Rice
Fields – Tashibunosho* (2016).
Digital work, six channels,
more than 1,000 years.

teamLab, *Flutter of
Butterflies Beyond Borders,
Ephemeral Life Born from
People* (2018). Endless
interactive digital installation.
Sound: Hideaki Takahashi

←← teamLab, *Impermanent Life:
People Create Space and
Time, at the Confluence of
their Spacetime New Space
and Time is Born* (2018).
Interactive digital installation.
Sound: Hideaki Takahashi

As digital technology becomes woven even
more tightly into the fabric of our lives, we risk losing
touch with nature, our physical environment and our
own bodies. Instead of exacerbating this disjuncture,
teamLab exploits the expressive potential of the
digital medium to help visitors regain their sense
of physicality and connectedness to nature. In so
doing it enhances and transforms their interactions
with the environment and one another.

    In the artworks of *Future World* visitors become
instigators of change through their actions or
presence, echoing how our actions can impact

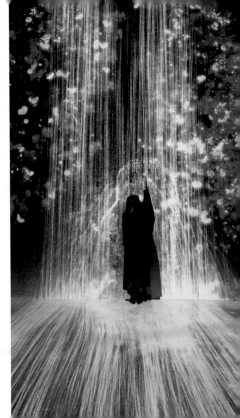

→
teamLab, *Universe of Water Particles, Transcending Boundaries* (2017). Interactive digital installation.
Sound: Hideaki Takahashi

teamLab, *Flowers and People, Cannot be Controlled but Live Together – Transcending Boundaries, A Whole Year per Hour* (2017). Interactive digital installation.
Sound: Hideaki Takahashi

the world around us and prompting visitors to reflect upon our existence as part of a vast universe. Visitors are no longer merely viewers of a static image or artwork; instead, they become active participants and creators as they are embedded in the artwork.

teamLab utilises 'ultrasubjective space' – in which 3D images are flattened – to create a space where the viewer is no longer holding a dominant perspective over the depicted space; instead visitor and artwork are merged into a comprehensive experience. This reinvention, which transcends the boundaries between viewer, artist and artwork, is further explored as the interactive nature of the artworks allows viewers to discover new perceptions of the world, the relationship between the self and the world, and of the continuity of time.

*Of Nature, Our Urban Condition and the Universe*
Our relationship with nature, interactions with our urban landscape and physical environment, as well as the wonder of the universe, are recurring themes of the artworks in *Future World*. Some of the works in the show evoke contemplation and reflection; others encourage play and physical activity.

The exhibition explores humans' relationship with nature in an urban landscape. The harmonious coexistence of urban structures with nature is increasingly important today, when more than half the world's population live in cities. By evoking nature's beauty and tranquillity, many of teamLab's artworks remind us of the integral role that nature plays in our daily lives and the continuity between humanity and the world.

The opening gallery in the exhibition is titled *Transcending Boundaries*. It is a collection of six striking artworks that allude to nature's fragility, beauty and power. In these works visitors are greeted by a breathtaking digital waterfall that cascades from the ceiling to the floor, forming streams and bodies of water; from this a virtual sea of flowers blooms and falls. The trajectory of the water changes as it detects the visitors' presence, causing the water to flow around each person and opening portals that reveal blooming flowers. The flowers gently blossom due to the presence of the viewers, then scatter and die when the visitors move. The seasons within the artwork dictate the type of flowers growing and dying at that time.

The *Transcending Boundaries* gallery is a reactive and generative visual landscape, created algorithmically through software. Elements from one artwork impact upon and interact with elements from others sharing the same space. The artworks further react to the presence of visitors in the space, responding to their behaviour. Such interactivity reminds us of the interdependent, symbiotic relationship between human beings and the world.

↓
teamLab, Exhibition view of *Future World: Where Art Meets Science*, ArtScience Museum Singapore, 2016.

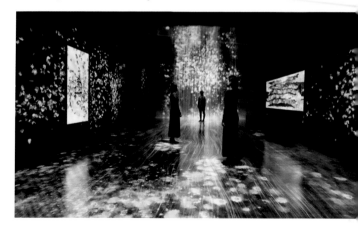

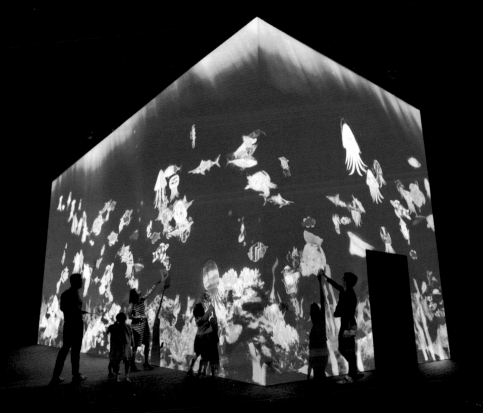

Echoing the generative forces of nature, new visual landscapes are constantly created, with no two moments the same.

Another work that celebrates the forces of nature is *Story of the Time when Gods were Everywhere*. In this captivating work pictographs represent elements of nature such as wind, rain, trees and mountains. Once touched, the characters transform into images of what they symbolise. Once materialised, the elements may influence each other to create a new visual story scripted by the interaction of different elements and people.

Popular with all ages, both young and young at heart, the artwork *Sliding through the Fruit Field* imbues visitors with a life-giving force if they choose to slide down a slope filled with digital fruit and flowers. The sliding motion of these visitors kickstarts the plants' life cycles, triggering flowers to bloom and fruit to burst and spread their seeds.

One of the centrepieces of *Future World* is *Sketch Aquarium*. Here a virtual aquatic ecosystem is created through the drawing and colouring of sea creatures contributed by visitors. As visitors scan and upload their individual works, they can see their creations

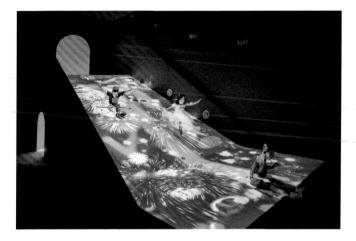

come 'to life' in the giant virtual aquarium. Visitors can also interact with the ecosystem, making schools of fish gather by feeding the sea creatures virtual food from food bags, which appear randomly, or scaring the animals away by virtually touching them.

In allowing visitors to design and create their own experiences, teamLab encourages and emphasises collaboration and partnership. In *Inverted Globe, Giant*

↑
teamLab, *Sliding through the Fruit Field* (2016). Interactive digital installation.

←←
teamLab, *Sketch Aquarium* (2013). Interactive digital installation.
Sound: Hideaki Takahashi

→→
teamLab, *Inverted Globe,
Giant Connecting Block
Town* (2018). Interactive
digital installation.
Sound: Hideaki Takahashi

↓
teamLab, *Light Ball Orchestra*
(2013). Interactive installation.
Sound: teamLab

*Connecting Block Town*, visitors work together to design and create their own transportation network. Giant building blocks representing houses and transport hubs can be connected to build a network of roads, railways and rivers to be used by trains, cars, aeroplanes and boats. As more blocks are connected, the transportation system evolves and the cityscape changes. Nature and its impact upon human infrastructure is not forgotten: a river runs

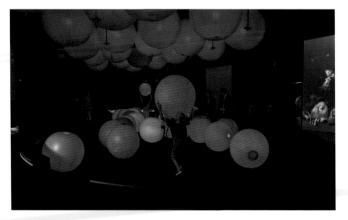

through the city, able to overflow and flood the city when it rains. Blocks representing ponds can then be used to prevent flooding by locating them near rivers to create more waterways.

Active learning and creativity thus take place through processes of exploration and collaboration. This consistent feature of the work of teamLab aligns very closely with themes explored by ArtScience Museum and its exhibitions and programmes.

Collective and collaborative play is encouraged in many of teamLab's works. The interactive installation *Light Ball Orchestra* expands on this by engendering spontaneous play. In this work large, illuminated spheres change colour and produce different sounds in response to visitors touching and rolling them. The 'light balls' also communicate with one another, creating a symphony of sound and colour.

*Crystal Universe*, the final highlight of *Future World*, startles visitors with its beauty, magnitude and scale. Comprised of thousands of LED lights set in a mirrored space, this monumental installation is both a sculptural work of art and a light-infused space which visitors can enter and interact with. By using smartphones — or a tablet provided in the space —

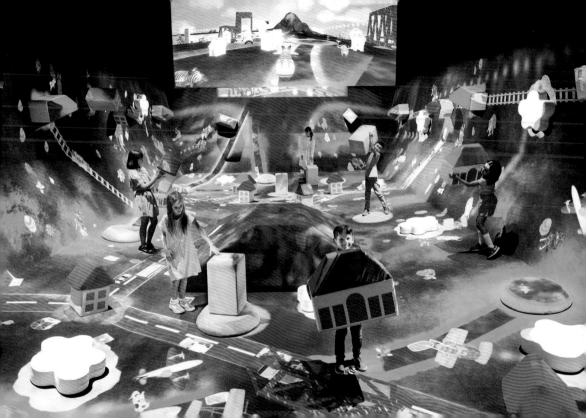

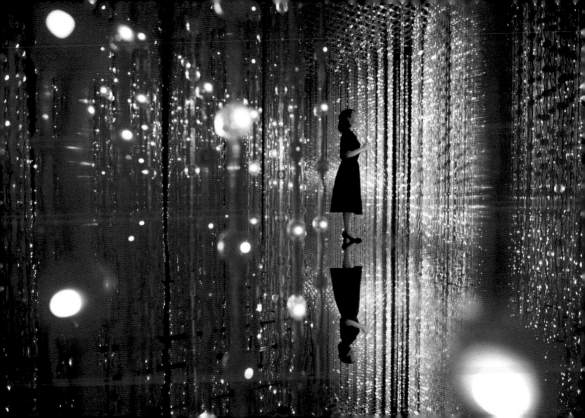

visitors select stars, planets and other astronomical elements to add to the crystal universe, thereby influencing its formation. A hypnotic score underlies and completes the experience, taking visitors on an aesthetic and sonic journey through space. Whether you enter the installation itself or view it from outside, *Crystal Universe* fascinates and captivates with its magical illusion of space travel and close encounters with stars, planets and galaxies. This hugely popular work is often photographed and posted on many social media platforms.

←← ↙
teamLab, *Crystal Universe* (2015). Endless interactive light installation. LED lights. Sound: teamLab

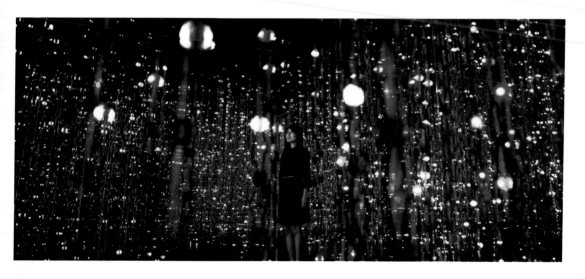

→
teamLab, *Life Survives by the Power of Life* (2011). Digital work, 6 mins, 23 secs (loop). Calligraphy: Sisyu

→→
teamLab, *Sketch Town* (2014). Interactive digital installation. Sound: Hideaki Takahashi

One of the future directions for exhibitions is a focus on the experiential and collaborative. ArtScience Museum's collaboration with teamLab in creating *Future World* anticipates this direction. Drawing upon both technology and art, the works in *Future World* change as technology advances and as society and nature evolve.

*The digital realm, free from physical constraints, allows for unlimited possibilities of expression and transformation.*
— teamLab

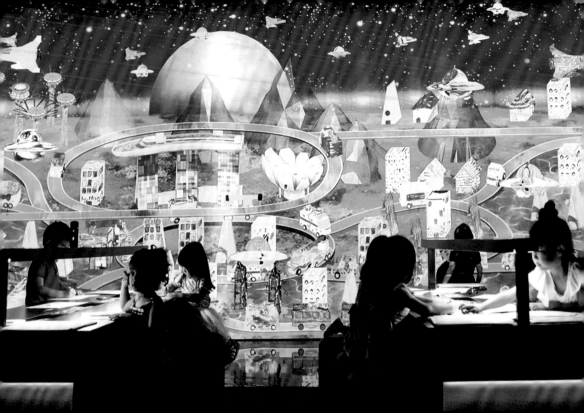

An original drawing of
*Codex Atlanticus* (1478–1519)
on display at the exhibition
of 2014.

→→
Leonardo da Vinci's
inventions *Flying Machine* and
*Parachute* on display at the
*Da Vinci: Shaping the Future*
exhibition, 2014.

## DA VINCI: SHAPING THE FUTURE

The exhibition *Da Vinci: Shaping the Future* (2014) was the first of many exhibitions that fully expressed ArtScience Museum's mission to bring together art, science, technology and culture. No figure is more iconic to the union of art and science than Leonardo da Vinci (1452–1519), a true Renaissance man who worked fluidly between disciplines as diverse as mathematics, natural sciences, architecture, technology and music.

To create this exhibition, ArtScience Museum worked with the Biblioteca Ambrosiana in Milan, Italy to bring original masterpieces by Leonardo to South-East Asia for the first time. The exhibition, displayed over 3,000 square metres, showcased original pages from the *Codex Atlanticus* – the largest collection of writings and drawings by Leonardo da Vinci – alongside paintings from the School of Leonardo, interactive models and audiovisual displays that illustrated Leonardo's systematic way of thinking.

Leonardo made a startling number of new discoveries and inventions. Centuries before the Wright Brothers pioneered mechanised flight, Leonardo explored flight through his studies of birds and designed a multitude of mechanical flying devices. A highlight of the exhibition was a large aerial model of one of his winged devices that appears strikingly similar to a modern aircraft.

The exhibition was organised into five thematic chapters, each of which illustrated a core area of Leonardo's practice – Mathematics, Natural Sciences, Architecture, Technology and Music. Each of these chapters included a contemporary art installation which explored the legacy of Leonardo's work

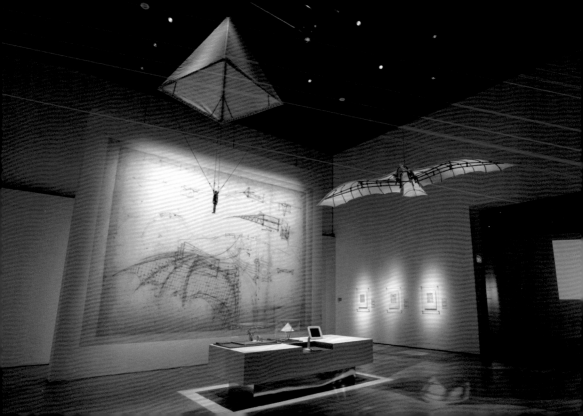

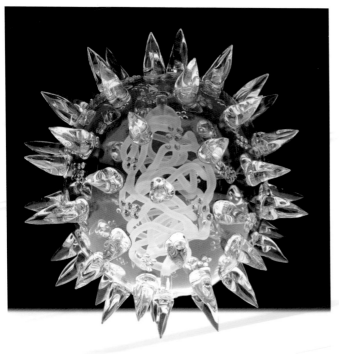

The installations by Luke Jerram, Donna Ong, Semiconductor, Conrad Shawcross and WY-TO revealed how Leonardo's ideas and thinking still resonate deeply today. One of the contemporary artworks on display was *Glass Microbiology* (2004) by British artist Luke Jerram. These stunning glass sculptures represented viruses and other microscopic organisms. Echoing the illustrative drawings of nature made by Leonardo in the *Codex Atlanticus*, Jerram's sculptures reveal the hidden structures of naturally occurring phenomena.

Leonardo's interdisciplinary approach to the understanding of nature remains relevant in addressing many pressing challenges that we face today, an insight beautifully evoked in this landmark exhibition.

## JOURNEY TO INFINITY:
## ESCHER'S WORLD OF WONDER

Renowned for his enigmatic artworks and paradoxical designs, the Dutch artist M.C. Escher (1898–1972) is lauded by the international scientific community for his works. Escher's art celebrates the confluence of art and science, displaying a keen observation of nature, a fascination with architectural space and an exploration of mathematical models.

*Journey to Infinity: Escher's World of Wonder* (2016) was a major retrospective exhibition. It featured over 150 original artworks, ranging from the artist's early prints inspired by the landscape

Luke Jerram's *Glass Microbiology* (2004) on display at *Da Vinci: Shaping the Future* exhibition, 2014.

Escher was fascinated by the problem of depicting perspective; he created peculiar and impossible environments as a result. *The Relativity Room*, part of the exhibition design, played with proportion and created an illusion of distorted size.

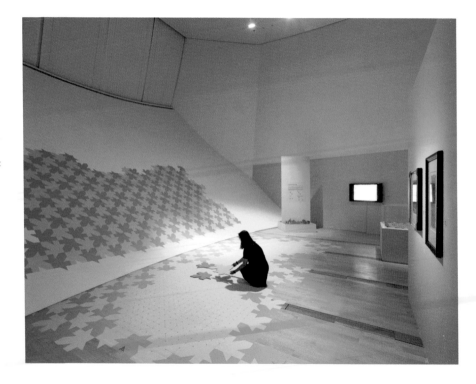

→

Through this large-scale, Escher-inspired puzzle, visitors discovered the four principles of tessellation and its limitless potential.

→→

Some of M.C. Escher's most famous works – including *Relativity* (1953), *Print Gallery* (1956) and *Ascending and Descending* (1960) – highlight his attempts to represent the limitless. In *Relativity* Escher creates a surreal and yet realistic world by mixing perspective based on three different points.

of Italy to his renowned masterworks on tessellation and the transformation of shapes. Like the Leonardo exhibition, this showcase of Escher's work was a perfect fit for ArtScience Museum. Escher's astute systematic thinking aligned with the Museum's exploration of cross-disciplinary creativity.

Although Escher's art was substantially grounded in mathematics, in particular geometry, his understanding of mathematics was largely visual and intuitive. He played with errors in perspective to construct impossible spaces and optical illusions, exploiting the interaction of negative and positive space to create his enigmatic works. Metamorphosis and representations of infinity defined Escher's art, which in turn seamlessly blended fantasy and geometry. Many of his works have fascinated and astounded generations of artists, architects, mathematicians, musicians and designers. *Journey to Infinity* went on to explore the impact of his works on contemporary popular culture, especially art, fashion, design, music and film.

↓
*wave is my nature* (2015/2019), a kinetic spatial light installation by Russian artist ::vtol::, simulates Feynman's theory about the movement of light. The installation simultaneously takes all possible paths while moving from one point to another. The artwork reacts to the presence of visitors, creating an autonomous sound and light composition when activated.

## ALL POSSIBLE PATHS: RICHARD FEYNMAN'S CURIOUS LIFE

*All Possible Paths: Richard Feynman's Curious Life* (2018–19) was an exhibition about the pioneering theoretical physicist Richard Feynman, curated for the centenary of his birth. The Nobel Prize-winning scientist (1918–88) was best known for his work on quantum mechanics, the basis of modern physics, and for establishing theories that paved the way for many technological advances that now support our everyday lives.

The exhibition was curated and produced by ArtScience Museum, in collaboration with Nanyang Technological University, National University of Singapore, Caltech and the Nobel Museum in Sweden. Inspired by Feynman's highly visual way of thinking, the exhibition's curators articulated the abstract world of quantum physics and explored its applications using contemporary art. As a result, the exhibition offered visitors an opportunity to engage more deeply in his complex scientific thought through the medium of art, drawing upon commissioned contemporary installations, sculptures and immersive environments by artists such as Markos Kay, Monika Lelonek, Jun Ong, Eiji Sumi, Edward Tufte, Frederik De Wilde and ::vtol::.

*All Possible Paths* explored Feynman the person, his fascinating life, his artistic interests and his quirks, as well as reflecting on his legacy. It gave an insight into a creative intelligence that allowed Feynman to view things differently from most of his peers. The show included a collection of his sketches, paintings, photographs and musical instruments, lent by his family, that were displayed in public for the first time outside of the USA. These unique personal artefacts enabled the show to capture Feynman's illustrious life, curious nature and flamboyant personality.

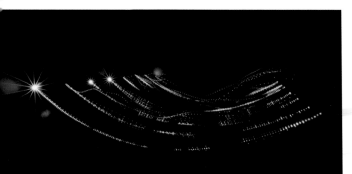

Feynman studied physics at the Massachusetts Institute of Technology before going on to have a celebrated teaching career at the California Institute of Technology. Outside of teaching, he worked on the Manhattan Project – a research project that led to the building of the first atomic bomb – and later in his life played an integral role in investigating the Challenger Space Shuttle disaster in 1986. However, Feynman was best known for his pioneering work in fundamental particle physics. In 1965 he was awarded the Nobel Prize in Physics, along with Julian Schwinger and Shinichiro Tomonaga, for his research into the behaviour of elementary particles. His work was presented as a series of drawings that have become known as the 'Feynman diagrams'. These visualisations of elementary particle interactions were to change for ever the way in which physicists think.

Not only skilled in science, Feynman earned a reputation as a musician, a puzzle solver and an enthusiastic prankster. Known as the 'Great Explainer', Feynman had a natural ability to convey complex ideas to both scientists and the public in a fun and accessible way. He believed that in order to comprehend anything fully, one had to be able to teach it to someone else. His passion for thinking, learning and teaching is chiefly what inspired his students, many of whom also became award-winning scientists.

Like many of the previous monographic shows ArtScience Museum has curated, *All Possible Paths* went beyond biography. As the title of the exhibition suggests, it charted different pathways and perspectives on the pursuit of knowledge and our understanding of the world.

↑
*Quantum Foam #2* (2018) by artist Frederik De Wilde is a sculptural work inspired by the Uncertainty Principle of quantum mechanics. According to this, when space-time is examined at a fantastically small scale it appears to fluctuate wildly, resembling the turbulent surface of boiling water.

→
Ryoji Ikeda's *data.tron*
*[WUXGA version]* (2007)
makes the imperceptible sea
of data that permeates our
world dramatically visible
and audible through digital
projection and sound.

→→
Through the mapping of
data on illuminated spheres in
*World Processor* (1989–2015),
Ingo Günther employs globes
as representational forms to
communicate the challenges
of comprehending the world's
data reality.

## BIG BANG DATA

The exhibition *Big Bang Data* (2016) explored
the role of data in our lives through visually
powerful installations by artists and research
projects by journalists, geographers, technologists
and film-makers.

In the twenty-first century the amount of data
we generate from the use of our smart devices and
online activities is astronomical. From scientific
research to business, politics to social interaction,
the volume of data created by us has transformed our
lives, impacting how we make decisions. Curated by
Olga Subirós and José Luis de Vicente, *Big Bang Data*
made data tangible and visible, increasing visitors'
awareness of its sheer volume and potential. The
show critically examined how data can be tapped to
serve different purposes. On the one hand it can be
used to promote a more participatory and democratic
society. On the other it can be turned into a means
of mass surveillance. *Big Bang Data* provided visitors
to ArtScience Museum with tools to understand how
data is stored, generated, processed and interpreted,
and gave form to the invisible data generated by us all.

The participants of *Big Bang Data* included
some of the most important names in digital art
and culture including Timo Arnall, Lise Autogena,
Christopher Baker, James Bridle, Ingo Günther,
Heather Dewey-Hagborg, Ryoji Ikeda, Aaron Koblin,
Stephanie Posavec and Joshua Portway.

Like many of ArtScience Museum's exhibitions
that explore contemporary themes, *Big Bang Data*
asked visitors to confront difficult questions
regarding the ethics and social issues raised by
the show. In doing so, it invited visitors to reflect
upon the true meaning of the data explosion in
our current digital age.

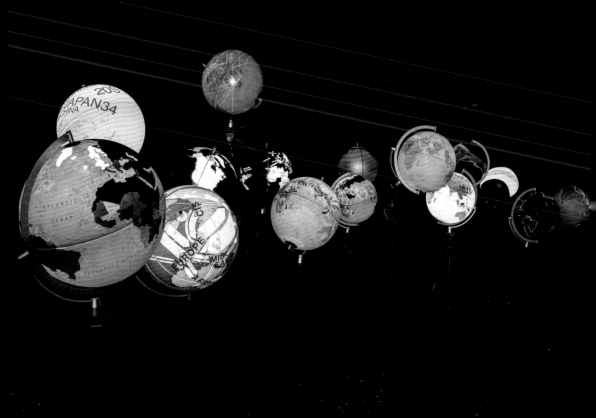

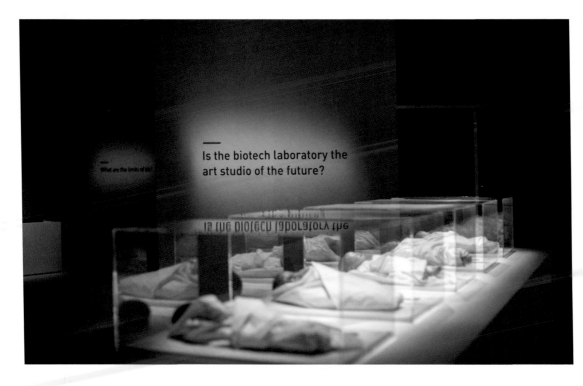

Is the biotech laboratory the art studio of the future?

## HUMAN+ THE FUTURE OF OUR SPECIES

HUMAN+ (2017) explored the future of human beings. A collaboration between ArtScience Museum, The Centre de Cultura Contemporània de Barcelona and Science Gallery Dublin, this cutting-edge exhibition asked what it means to be human in a world of artificial intelligence, lifelike robots and genetic modification. It probed the social, ethical and environmental questions raised by using technology to modify ourselves.

Advances in genetic engineering, biotechnology and nanotechnology that not long ago seemed purely science fiction are now real. Cyborgs, superhumans and clones are alive among us today. HUMAN+ asked what does it mean to be human now? What will it feel like to be a human a hundred years from now? Should we continue to embrace modifications to our minds, bodies and daily lives, or are there boundaries over which we should not step?

Showcasing the work of 40 international artists, scientists, technologists and designers, HUMAN+ explored possible future paths for our species. It included major names from the fields of robotics, biotechnology, synthetic biology and artificial intelligence, including the world's first living cyborg, Neil Harbisson, Australia's leading performance artist Stelarc and bio-artists Oron Catts and Ionat Zurr, who grow sculptures from living tissue. Other participants included Louis-Philippe Demers, Agi Haines, Robert Zhao Renhui, ORLAN, Howard Schatz, Addie Wagenknecht and more.

From spectacular demonstrations of the latest robotic technologies to challenging contemporary artworks, intriguing design prototypes and exciting innovations from Singapore, HUMAN+ was one in a series of exhibitions ArtScience Museum has staged which imagine many possible futures. It vividly showed how science and technology are constantly transforming our perception of humanity.

←←
Transfigurations (2013) by Agi Haines depicts designs for potential body enhancements on babies. The work explores how these can 'solve' potential future problems, from medical to environmental and social mobility issues, while questioning the physical, mental, social and economic costs to society.

Conrad Shawcross's *Slow Arc Inside a Cube VIII* (2017) reflects on the mysterious universe, 96 per cent of which is unknown. Inspired by Dorothy Hodgkin, the Nobel Prize winning biochemist who described crystal radiography as 'trying to work out the structure of a tree from seeing only its shadow', the work evokes the art of trying to visualise the invisible.

## THE UNIVERSE AND ART

The universe has long inspired humanity in mythology, philosophy and art. Its presence, mysteries and wonders have made it an object of veneration, contemplation, inspiration and study. *The Universe and Art* (2017) was an artistic voyage through space, exploring where we came from and where we are going. It was curated by Fumio Nanjo and Reiko Tsubaki from Mori Art Museum in Tokyo – the exhibition co-producers – and Honor Harger from ArtScience Museum.

The exhibition wove together a rich constellation of Eastern and Western philosophies, ancient and contemporary art, science and religion to explore how humanity has constantly contemplated its presence in the universe. It began with a focus on historical cosmologies from around the world, including religious art from the Buddhist, Hindu and Jain traditions, on loan from Asian Civilisations Museum in Singapore. The birth of astronomy as a science was charted through a remarkable collection of artefacts from East and West, including masterpieces by Copernicus, Galileo,

Kepler and Newton that were on show in Singapore for the first time.

New scientific thinking on the universe was examined through artworks by contemporary artists, including Björn Dahlem, Andreas Gursky, Mariko Mori, Wolfgang Tillmans and a new commission by Conrad Shawcross. As the show continued, it explored the origin of life in the cosmos through artworks by major figures such as Laurent Grasso, Pierre Huyghe, Patricia Piccinini and Hiroshi Sugimoto. *The Universe and Art* ended by pondering life in space through the work of historical pioneer Konstantin Tsiolkovsky and the evolution of space art, including artworks by Kitsuo Dubois, Takuro Osaka, Arthur Woods and Dragan Živadinov designed for space stations.

*The Universe and Art* was a potent confluence between the terrestrial and the celestial, the real and the fictional, the poetic and the technological. In keeping with ArtScience Museum's mission, it was truly a place where art and science met.

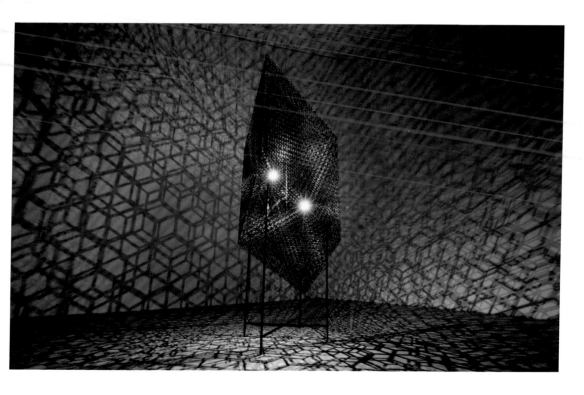

Olafur Eliasson's *Seu corpo da obra (Your body of work)* (2011) invites audiences to experiment with their own perceptions of space and colour.

### MINIMALISM: SPACE. LIGHT. OBJECT

*Minimalism: Space. Light. Object* (2018–19) saw ArtScience Museum partnering with a neighbouring museum, the National Gallery Singapore, to present South-East Asia's first survey exhibition on minimalism.

Through painting, sculpture, installation, performance and music, the exhibition showed how minimalism became a turning point in the history of twentieth-century art. Minimalism emerged as a major tendency in 1960s New York, but its roots can be traced back to much earlier Asian philosophies and artistic styles. By paring artworks down to their essential elements, minimalist artists sought to strip away individual expression and artistic decision-making and create a direct encounter between the viewer and the artwork.

The exhibition featured more than 150 works of art by over 80 artists and 40 composers. At National Gallery Singapore, visitors could trace the development and rich legacies of minimalist art and ideas from the 1950s to the present day. At ArtScience Museum, the exhibition delved into Asian philosophy, exploring the impact of these ideas on artists across the world. The works at ArtScience Museum reflected on the profound simplicity and stillness inherent in Eastern interpretations of minimalism, while embodying the bare, angular starkness that made it such a vital force in the West during the 1960s.

*Minimalism: Space. Light. Object* included significant works by canonical names in the movement, including Carmen Hererra, Donald Judd and Richard Long, as well as key contemporary figures such as Olafur Eliasson and Anish Kapoor. Minimalism as seen in Zen, Chinese maximalism and contemporary abstraction was explored through works by CharWai Tsai, Song Dong, Tan Ping, Wang Jian, Morgan Wong and Zhou HongBin. Playing to its strengths as a museum of art and science, ArtScience Museum also presented artworks which meditated on the notions of the cosmological void, emptiness and nothingness – principles that resonate with both minimalism and science.

*Minimalism: Space. Light. Object* was curated by Silke Schmickl, Russell Storer and Eugene Tan from National Gallery and Adrian George and Honor Harger from ArtScience Museum.

Overall it sought to express the idea, often attributed to Albert Einstein, that 'everything should be made as simple as possible, but not simpler'.

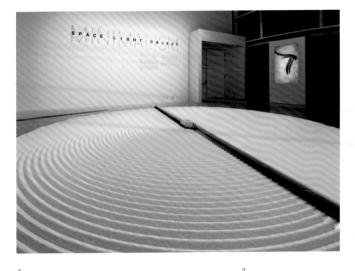

↑
Mona Hatoum's circular sculpture at the centre of the gallery takes inspiration from Japanese Zen gardens. *+ and −* (1994–2004) mechanises the process of creation and destruction. The work contains over 750 kg of sand and rotates at a rate of five revolutions per minute. Its repeated sweeping movements and hypnotic sound evoke both absence and presence, existence and non-existence.

↗
teamLab, *Enso* (2017). Digital work. Single channel, 18 mins 30 secs (loop).

## INTO THE WILD

→
Brian Gothong Tan's animated film *Into the Wild* featured five endangered animals in South-East Asia – pangolins, tapirs, mousedeer, orangutans and tigers – and explored their fragile habitat.

*Into the Wild* (2017–19) was a mixed-reality experience that transformed over 1,000 square metres of ArtScience Museum into a virtual rainforest, which visitors explored using a smartphone device. It was made by ArtScience Museum, the World Wide Fund for Nature (WWF), technology giants Google and Lenovo, Singaporean artist Brian Gothong Tan and creative studio Media Monks.

Visitors began their journeys in an augmented reality base camp before adventuring into a lush jungle. As they traversed into the unknown, visitors experienced wild animals in their natural habitat as well as witnessing the devastating effects of deforestation and hunting at first hand. Each visitor assumed the role of a wildlife ranger and took action to defend the animals from destruction, poaching and the threat of fire. The experience culminated with the visitor planting their own virtual tree in the Museum's rainforest.

What made the project truly different was its engagement with real-world conservation action. For every virtual tree planted in the virtual forest, and accompanied with a pledge to WWF, a real tree was

planted in a rainforest in neighbouring Sumatra, Indonesia. Over the lifespan of the project ArtScience Museum's visitors were responsible for planting 10,000 new trees in Rimbang Baling, one of the last pristine rainforests in Sumatra and a vital territory for the critically endangered Sumatran tiger.

*Into the Wild* was inspired by a desire to create a deeper awareness of the richness and fragility of South-East Asia's natural heritage. The augmented reality journey though the rainforest was shown alongside a film installation by Singaporean artist Brian Gothong Tan. Using state-of the-art animation and projection-mapping, Tan created a portal through which visitors were able to pass, moving from the augmented reality of the digital adventure into an immersive, cinematic world. The installation focused on the five animals featured in the augmented reality journey: pangolins, tapirs, mousedeer, orangutans and tigers, and followed them on a journey from creation to destruction and on to rebirth.

In 2018 *Into the Wild* won a Webby Award and four Spikes Asia awards in recognition of its significant technological innovation and its success in using art and technology to make a positive impact on the environment. The event stands as a shining example of a museum inspiring organisations to come together to transcend the virtual world and make a real difference to our precious natural environment.

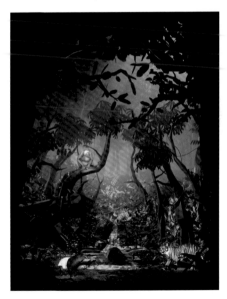

A still image from Brian Gothong Tan's immersive film *Into the Wild* (2017).

## REWILD OUR PLANET

*REWILD Our Planet* (2019) was an interactive exhibition based on *Our Planet*, the major natural history documentary series created by Netflix in partnership with WWF.

Marking the global launch of *Our Planet*, ArtScience Museum presented an exhibition that used cutting-edge technology to transport visitors to some of the world's most striking landscapes to show how climate change impacts all living creatures.

Blending IMAX-style projections with augmented reality, spatial soundscapes and a soundtrack narrated by David Attenborough, *REWILD Our Planet*

enabled ArtScience Museum's visitors to dive into the deepest oceans, visit the most remote forests and soar over vast ice caps. David Attenborough described it as 'a spectacular journey of discovery showcasing the beauty and fragility of our natural world'.

Jointly developed by ArtScience Museum, Google, Netflix, PHORIA and WWF, *REWILD Our Planet* combined art and technology to encourage visitors to play an active role in conservation. It focused on four of the natural landscapes featured in the documentary series 'Forests', 'Oceans', 'Grasslands' and 'Frozen Worlds'. Visitors learned about each ecosystem and the unique environmental challenges it faced. They were then encouraged to work together in small groups to reverse environmental damage by carrying out rewilding tasks such as planting trees, restoring damaged terrain and re-introducing animals back into their natural environments.

This unique project saw the convergence of natural history, broadcast entertainment, digital arts, cutting-edge technology and conservation. In 2020 the project received two Webby Awards in recognition of its success in using art and technology to mobilise global attention on environmental issues.

## 2219: FUTURES IMAGINED

2019 was the year of Singapore's Bicentennial which Artscience Museum chose to mark through a speculative rather than a reflective approach. The exhibition *2219: Futures Imagined* (2019–20) catapulted visitors 200 years into a possible future for Singapore. Visitors were invited to discover potential futures of Singapore through a series of immersive installations, meditative spaces, films, paintings and sculptures.

While many of the adaptations, evolutions and advancements proposed were speculative, the exhibition was anchored in the scientific certainty that changes to our climate will lead to necessary changes in our culture, traditions and communities.

The exhibition was curated by ArtScience Museum and based on an idea by Singaporean writer and poet Alvin Pang. It mapped out scenarios presented in the form of five acts: 'Arrival', 'Home', 'Underworld', 'Adaptation' and 'Memory'. Each section captured a moment that had occurred in the imaginary future between 2019 and 2219. The first act opened with the year 2019, confronting visitors head-on with the environmental destruction that

had already taken place. John Akomfrah's *Purple* (2017), an immersive, six-channel video installation, provided the launch pad for visitors about to explore the future. Combining found footage with haunting images of present-day landscapes altered by global warming, the work featured a hypnotic, symphonic score that filled the space with 15.1 surround sound.

The next act, 'Home', considered how climate change, rising sea levels and disruptions to global trade might affect our lives and homes, leading us to prioritise self-sustainability over possessions. The third act explored a possible new subterranean

↓
Purple is the colour of mourning in Ghana. In this work, also titled *Purple* (2017), artist John Akomfrah reflects on the devastating effect of human activity on our planet. Consisting of hundreds of hours of archival footage interwoven with newly shot film and a mesmerising symphonic soundtrack, *Purple* addresses the implications and effects of climate change on human communities, biodiversity and the wilderness.

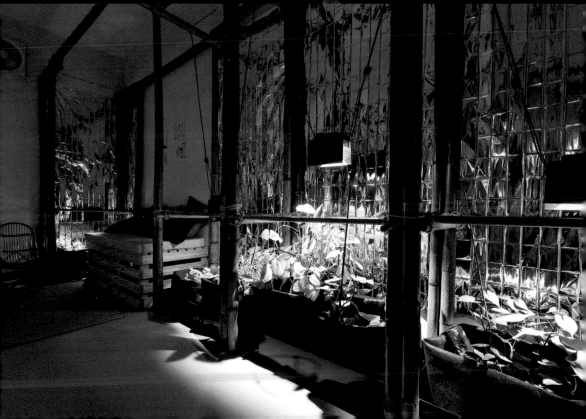

world which would be a replacement for the uninhabitable surface. Titled 'Underworld', it investigated our changing relationship with an increasingly rarefied nature and one another, as humans are forced to move beneath the Earth's surface. The fourth act, 'Adaptation', explored a future in which infrastructure has broken down and societies have fragmented and adapted in dramatically different ways. Air pollution, rising sea levels, limited natural resources and other issues have pushed humans into becoming a minority species while revealing a surprising successor, jellyfish. The last act, 'Memory', showed our return to the surface and celebrated the values of what survived. Meaningful objects in the form of relics and cultural traditions that were held dear and passed down, the rituals we repeat and the stories we tell are what form our collective memories and shared customs.

Proposing neither a utopia nor a dystopia, the exhibition broke free of familiar science fiction clichés by focusing on every day, intimate moments of human resilience, perseverance, resourcefulness and adaptability. The surprisingly intimate lens through which the future was seen encouraged visitors to reflect on the future they wanted for Singapore, and for the planet, and what they were prepared to do to bring such a future into being. *2219: Futures Imagined* showed us all that the global issues affecting our environment are real, acute and imminent. Extraordinarily prescient, the exhibition explored human resilience just as the world encountered the unprecedented COVID-19 pandemic.

ArtScience Museum's vision of the future was conveyed to the visitor through the work of artists such as Larry Achiampong, John Akomfrah, Yanyun Chen, Gordon Cheung, Clara Chow, Fyerool Darma, Priyageetha Dia, Debbie Ding, Finbarr Fallon, Johann Fauzi, Amanda Heng, Rachel Heng, Tristan Jakob-Hoff, Judith Huang, Shan Hur, Joshua Ip, Sarah Choo Jing, Adeline Kueh, Zarina Muhammad, Donna Ong, Hafiz Ozman, Alvin Pang, Lisa Park, Rimini Protokoll, Robert Zhao Renhui, Bao Songyu, Pomeroy Studio, Superflux and WOHA Architects.

←←
*Mitigation of Shock (Singapore Edition)* (2019) by London-based studio Superflux is an invitation to experience the lived consequences of global warming on a human scale. This installation takes the form of a speculative apartment transporting visitors to a Singaporean Housing Development Board (HDB) flat in the mid-21st century to investigate climate change and its consequences for food security.

## PROGRAMMES

Ranging from the thought-provoking to the edgy and experimental, ArtScience Museum's wide spectrum of educational and public programmes caters to all through a rolling, evolving series of events and activities.

The Museum's core educational offerings include regular school programmes as well as engaging and hands-on workshops. Designed to foster curiosity and encourage exploration and experimentation, its educational programmes take learning beyond books in the classroom and into the wider world.

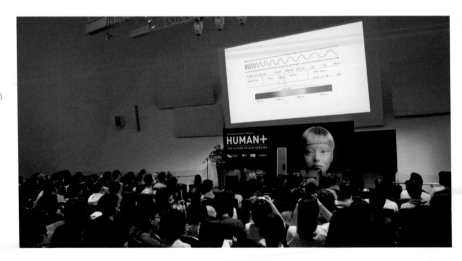

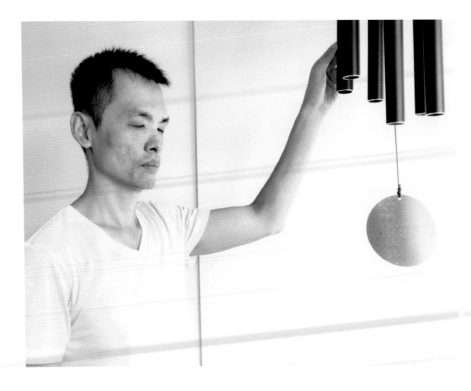

→
*Morning, To Meet Your Sky*, and *Practical Aim*, a performance by poet Cyril Wong as part of *ArtScience at Home* (2020). The work featured song and spoken words accompanied by wind chimes.

Multi-disciplinary and highly inspiring, ArtScience Museum's public programme staples include *ArtScience Late*, *ArtScience on Screen*, *Conversations* and *ArtScience at Home*. The Museum is transformed into a night-time venue on every third Thursday of the month for music, dance, theatre and other live performances. *ArtScience Late* attracts a young adult crowd and presents a cornucopia of experimental works by outstanding musicians and performers who often engage with concepts of art, technology and science. The majority of these events are free to the public and spotlight local and international performers such as Dan Deacon, Gazelle Twin, Ryoji Ikeda and Zul Mahmod.

Another popular offering at ArtScience Museum is the dedicated film and video programme *ArtScience on Screen*. Featuring Asian premieres of major new productions, screenings of artists' moving images, feature films, documentaries and short films, *ArtScience on Screen* also reflects the Museum's commitment to using diverse forms of art and technology to communicate and explore global issues.

Just as inspiring and stimulating is *Conversations*. This programme of talks, seminars and symposia at ArtScience Museum connects and gives a stage to experts, leaders and practitioners of different disciplines. Notable speakers include Dr Jane Goodall (primatologist), Neil Harbisson (cyborg artist), Dr Peter Jenni (co-founder of the ATLAS experiment at CERN), Sir Harold Walter Kroto (Nobel Laureate), Professor Dava Newman (Deputy Administrator of NASA) and Lord Martin Rees (the Astronomer Royal). *Conversations* events are often curated to explore in depth a particular aspect of the Museum's exhibition programme, providing opportunities for audiences to meet local and international researchers and ground-breaking artists and performers.

The '*Stand Up Speak Out!*' workshop (2019). During the course of the workshop participants identified issues they felt passionately about, then created banners and inflatable sculptures to share their views.

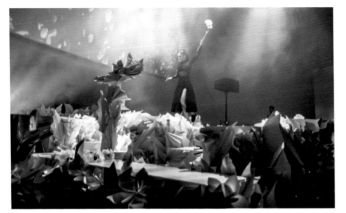

The COVID-19 pandemic created the opportunity to build a more versatile and deeper form of audience engagement through virtual platforms. *ArtScience at Home* reflects the Museum's adaptive and flexible spirit by responding to the global pandemic with a renewed focus on online programmes. *Feeling the Future*, an online conference series, attempts to explore alternative ways of thinking about the future while navigating current uncertainties. With the suspension of large-scale public gatherings and performances during the pandemic outbreak, *ArtScience Late at Home* series was born. In this artists are invited to improvise and create short performance pieces which are then broadcast directly from their homes. In its inaugural performance poet Cyril Wong delivered a meditative and haunting piece, interweaving verses from his love poems with sounds of wind chimes and singing. In order to support the local community of creatives, the Museum also launched a series of micro-commissions. For this series of new works, local film-makers are invited to create very short films intended to be viewed on social media; these are then filmed using existing tools or found footage.

*We need both the understanding generated by science and the emotional connections made possible through art. Neither alone can effect meaningful transformations on a global or societal level. It is the two fields, in dialogue, that are most likely to create possible new futures.*
– Honor Harger, Vice President, ArtScience Museum at Marina Bay Sands

## IT IS HERE THAT THE FUTURE IS MADE

From its iconic design to its award-winning sustainability features, the Museum building itself embraces and embodies the desire for a better environment and a liveable future. The work of the Museum reveals a similar passion – a passion for the future. The inspiring vision set out for ArtScience Museum when it was first conceived has materialised. Despite being a relatively young institution compared to other museums in the region and across the world, ArtScience Museum has quickly established a reputation as a cultural institution of foresight – a museum with a vision for tomorrow. In connecting people and knowledge across disciplines, the Museum has become a unique point of intersection. It is here at these intersections – of art and science, of culture and technology, of people and ideas – that the future is made manifest.

←←
Another *ArtScience Late* event, *A Litany of Broken Prayer and Promise* (2020) by contemporary performance company CAKE, was a dreamlike expression of creation and destruction. The event was developed in collaboration with Singapore's foremost multi-disciplinary artists and performers.

←
teamLab, *Create! Hopscotch for Geniuses* (2015). Interactive digital installation. Sound: teamLab

© Scala Arts & Heritage Publishers Ltd 2022
Text © ArtScience Museum Singapore

First published in 2022 by
Scala Arts & Heritage Publishers Ltd
305 Access House
141–157 Acre Lane
London SW2 5UA
www.scalapublishers.com

In association with
ArtScience Museum Singapore
Marina Bay Sands Singapore
6 Bayfront Avenue
Singapore 018974
www.marinabaysands.com

British Library Cataloguing in Publication Data

A catalogue record for this book is available from the British Library.

ISBN 978 1 78551 310 7

Research and writing by Szan Tan and Honor Harger (ArtScience Museum Singapore)

Project editor Gail Chin

Edited by Catherine Bradley and Adrian George (ArtScience Museum Singapore)

Designed by Linda Lundin

Printed in China

Every effort has been made to acknowledge copyright of images where applicable. Any errors or omissions are unintentional and should be notified to the publisher, who will arrange for corrections to appear in any reprints.

Front cover: Exterior of ArtScience Museum Singapore by photographer Stephen Lee. An LED light stick, slow shutter speed and photo retouching software created what Lee refers to as an 'aurora by the bay' effect. Courtesy of Stephen Lee © Marina Bay Sands

Back cover: A still image taken from drone footage of ArtScience Museum Singapore.

## Picture Credits

All images © Marina Bay Sands except the following: teamLab, exhibition images at *Future World* (2016). Courtesy of Ikkan Art International, images © Marina Bay Sands, title page, pp. 24, 26–31 and 35; teamLab, *What a Loving, and Beautiful World – ArtScience Museum* (2016). Courtesy of Ikkan Art International, images © Marina Bay Sands, pp. 5 and 21; Courtesy of Safdie Architects, pp. 8–11; Courtesy of Dawn Ng Studio © Marina Bay Sands, p. 13; Theo Jansen, *Animaris Ordis* (2006) © Marina Bay Sands, p. 23; teamLab, exhibition images at *Future World* (2016). Courtesy of Ikkan Art International, pp. 25, 32–34 and 63; Courtesy of Veneranda Biblioteca Ambrosiana © Marina Bay Sands, pp. 36 and 37; *Untitled Future Mutation* (2004). Photo by Luke Jerram, p. 38; M.C. Escher, *Relativity* © 2020 The M.C. Escher Company, The Netherlands. All rights reserved. www.mcescher.com, p. 41; ::vtol::, *wave is my nature* (2015/2019). Courtesy of the artist © Marina Bay Sands, p. 42; Frederik De Wilde, *Quantum Foam #2* (2018). Courtesy of the artist © Marina Bay Sands, p. 43; Ryoji Ikeda, *data.tron [WUXGA version]*, audiovisual installation (2011) © Ryoji Ikeda. Courtesy of Marina Bay Sands, p. 44; Ingo Günther, *World Processor* © 2017 World-Processor.com and IngoGunther.com, p. 45; Agi Haines, *Transfigurations* (2013). Courtesy of the artist © Marina Bay Sands, p. 46; Conrad Shawcross, *Slow Arc Inside a Cube VIII* (2017). Courtesy of the artist © Marina Bay Sands, p. 49; Olafur Eliasson, *Seu corpa da obra (Your body of work)* (2011). Courtesy of Marina Bay Sands and neugerriemschneider © Marina Bay Sands, p. 50; Mona Hatoum, *+ and -* (1994–2004). Courtesy of Marina Bay Sands. Collection of Albright-Knox Art Gallery, Buffalo, New York; General Purchase Fund, 2007 (2007: 2a–d) © Marina Bay Sands, p. 51; teamLab, *Enso* (2017). Courtesy of Ikkan Art International © Marina Bay Sands, p. 51; Brian Gothong Tan, *Into the Wild* (2017). Pico Art International Pte Ltd in collaboration with the artist and CravelFX, pp 52–53; *REWILD Our Planet* (2019). Courtesy studio PHORIA, working with WWF, Google, Netflix and ArtScience Museum, with footage developed by Silverback Productions © Marina Bay Sands, p. 54; John Akomfrah, *Purple* (2017). Courtesy of Smoking Dog Films and Lisson Gallery © Marina Bay Sands, p. 55; Superflux, *Mitigation of Shock (Singapore Edition)* (2019) © Marina Bay Sands, p. 56.